佛光寺位于山西省五台县豆村镇佛光村南侧。寺内现存的东大殿为唐大中十一年（857）重建，文殊殿为金天会十五年（1137）重建，砖砌六边形祖师塔为北魏所建，东大殿前经幢为唐大中十一年（857）刊立，文殊殿院《佛顶尊胜陀罗尼经》经幢为唐乾符四年（877）刊立。寺内其他建筑多属明、清及近代所建。1961年，中华人民共和国国务院公布五台山佛光寺为全国重点文物保护单位。

佛光寺东大殿现有古代彩塑遗存333身，其中中央佛坛佛、菩萨、弟子、护法等35身，后檐墙及南北山墙内侧下方像台有罗汉296身，南尽间窗下墙体内侧有等身像1身。中央佛坛35身塑像中，有33身为唐代彩塑遗存。它们是中国国内仅存的一坛唐代宫廷泥质彩塑造像，代表着唐代造像的高超水准。

这33身唐塑，虽经后世多次补塑、重装，但基本保持了晚唐之际佛教彩塑造像的形态，其主要特点如下：

之《往五台山行记》

U0135191

中所记载的"廿七日夜见圣灯,一十八遍现,兼有大佛殿七间,中间三尊,两面文殊、普贤菩萨",应是大中年间东大殿重建后,殿内佛坛像设之具体格局。目前,东大殿中央佛坛有主像5尊,中间3尊为释迦、弥勒、阿弥陀佛像,左右2尊为普贤、文殊像,说明此殿中央佛坛现存塑像,仍保持着唐大中年间重塑此坛彩塑时的总体格局。

2. 唐塑造型样式犹存

中央佛坛现存的33身唐塑,虽经后世多次补塑、重装,但绝大多数的相貌、形体、衣着装饰等,仍完好地保存了唐大中年间塑绘时的原有面貌风格。

(1)33身唐塑中,除1身迦叶、2身天王、1身于阗王外,其他29身佛、菩萨、弟子等造像,皆面相丰盈、圆润,唐代样式基本未变。有唐一代,佛、菩萨造像一改魏晋南北朝瘦骨清像之风,转以丰肥浓丽为美。

(2)坛上14身胁侍菩萨和6身供养菩萨,大部分头戴花冠、青丝高挽、宝缯垂肩、袒胸露脐、披帛络腋、璎珞臂钏、裙裤紧窄、轻薄贴体,受印度帕拉造像造型、衣着、装饰等影响明显。但胁侍菩萨

的站姿并非帕拉造像的 S 形，而是基本呈直立形，在造型上已显示出"中国化"。比佛光寺东大殿佛坛尊像塑绘早 75 年的五台山南禅寺大佛殿内佛坛尊像，其胁侍菩萨站姿均为 S 形，两者区别明显。此项特征说明东大殿此坛彩塑完成了晚唐造型样式的本土化演变。

（3）中央佛坛所塑的胁侍、供养菩萨，是中原仅存的一坛体现唐代以丰腴为美的审美观念向宋代以清秀为美的审美观念过渡的彩塑实物遗存。这 14 身胁侍菩萨、6 身供养菩萨，皆塑绘为女相，虽然其面相大都保持盛中唐之际"曲眉丰颊"之样式风格，但双肩、双臂、双腿，与盛中唐菩萨塑像相比，形态已明显清秀、俊俏，尤其是身高大为拉长，腰围明显缩回，身姿已现颀长、俏秀之态，与晚唐、五代之际画作风格趋向一致，向宋代过渡的迹象明显。它们不仅在研究佛教造像由唐代向宋代审美样式过渡转变方面有独特的价值，而且也是此坛彩塑自唐大中年间塑绘完成至今依旧基本保持原有面貌的实证。

3. 唐代装銮层基本无存

虽然此坛唐塑的造型样式仍保持原有面貌基本未变，但其身上唐代装銮层除极少数隐藏部分外，绝大多数今已无存。现有装銮的大部分纹饰图案，应主要为明清重装时所绘，如三尊佛像所着龙袍等。但此坛塑像外在装銮层浓重的红、蓝等色彩，却大多为民国年间重装时的涂彩。

4. 塑像题材表现了大唐的兼容并蓄

此殿佛坛塑像，是盛中唐之际主要佛教造像的组合，表现了佛光寺作为唐代名寺、大寺所具有的兼容性和开放性。此坛塑像，共有5尊主像，3身为佛、2身为菩萨。其中的3身佛像，既非北朝之际已流行的燃灯、释迦、弥勒组成的"竖三世佛"，亦非宋以降较多出现的阿弥陀、释迦、药师组成的"横三世佛"，而是出现于北朝末而盛行于唐的"新三世佛"，即西方弥陀净土主佛阿弥陀佛、未来弥勒净土主佛弥勒佛、娑婆世界主佛释迦牟尼佛／华藏世界主佛毗卢遮那佛。它们反映了华严、法相、净土、密教等唐代几个主要佛教宗派在佛光寺东大殿的和谐并存。

Foguang Temple is situated in the south of Foguang Village, Doucun Town, Wutai County, Shanxi Province. What remains of the temple includes the East Main Hall rebuilt in the eleventh year of Dazhong Reign, Tang Dynasty (857 CE); the Manjusri Hall rebuilt in the fifteenth year of Tianhui Reign, Jin Dynasty (1137 CE); the brick-laid hexagonal Patriarch Pagoda built in the Northern Wei years; the sutra pillar in front of the East Main Hall established in the eleventh year of Dazhong Reign, Tang Dynasty (857 CE); and the Usnisa Vijaya Dharani sutra pillar in the courtyard of the Manjusri Hall established in the fourth year of Qianfu Reign, Tang Dynasty (877 CE). The rest of the structures in the temple are mostly constructed in Ming, Qing and modern times. In 1961, the State Council of the People' s Republic of China inscribed Foguang Temple on the list of the Major Historical and Cultural Sites Protected at the National Level.

Currently standing in the East Main Hall of Foguang Temple are 333 painted sculptures that are all invaluable cultural relics from the ancient past, including 35 statues of Buddhas, Bodhisattvas, disciples and guardians on the central altar; 296 statues of Arhats on a platform circling the altar and against the back

and side walls; and 1 life-sized statues under the window of the south end bay partition wall. Of the central altar group of 35 statues, 33 are Tang originals. These are the only remains in China of the painted clay statues sponsored by the imperial court of Tang Dynasty, and fine examples of the superb skills and standards of Tang sculptures.

The 33 Tang sculptures, although suffered various later time restorations and redecorations, still manage to keep a fairly good shape to exemplify the typical late Tang period Buddhist painted sculpture. The main characteristics of the group are as follows:

1. An intact setting of Tang sculptural group. It is recorded in *A Pilgrimage to Mt. Wutai* from the Dunhuang Archive that "the Holy Lamps were seen for 18 times within 27 days and 27 nights, and the Great Buddha Hall is seven bays wide, with three Buddhas in the middle, and Manjusri and Samantabhadra Bodhisattvas on the sides", which should be a specific description of the arrangement of the central altar after the East Main Hall was rebuilt during the Dazhong years. Currently there are five main statues on the central altar of the East Main Hall, with Sakyamuni, Maitreya and Amitabha Buddhas in the middle, and

Samantabhadra and Manjusri Bodhisattvas flanking the sides, indicating that the existing statues on the central altar still maintain the original arrangement of Dazhong years.

2. A conspicuous Tang style. The 33 remaining Tang sculptures on the central altar, although suffered various later time restorations and redecorations, still manage to keep a fairly good shape to exemplify the original Tang sculpture of the Dazhong period in terms of appearance, body shape, clothing and decorations.

(1) Most of the 33 Tang statues, except for Kasyapa, the 2 guardian kings and the King of Khotan, namely all the other 29 statues of Buddhas, Bodhisattvas and disciples appear plump, an indication of the uncompromised Tang style. In Tang Dynasty, Chinese Buddhist sculptures took a sharp turn from the Wei and Jin periods, when the "elegant structures and delicate features" were tremendously favored, to appreciate and admire the beauty of buxomness.

(2) Most of the acolyte and offering Bodhisattvas are bare-chested, with their heads wearing high chignons and coronets, upper bodies decorated with long

shawls, wreaths and bracelets, and lower bodies in slim and thin gowns. These plastic characteristics and decorative motifs are clear influences from India sculptures of the Pala Dynasty. Nonetheless the Bodhisattvas' postures appear to be standing up straight instead of showing a S-shaped curve—which is characteristic of a typical Pala torso—suggesting a localized style of the Foguang Temple sculptures. The statues in the Great Buddha Hall of nearby Nanchan Temple, which were created 75 years earlier than the central altar sculptures in the East Main Hall of Foguang Temple, and the acolyte Bodhisattvas there all hold a S-curve posture, therefore another clear proof that the East Main Hall statues are still maintaining their late Tang period style.

(3) The acolyte and offering Bodhisattvas on the central altar are the only extant examples, at least in the central part of China, of a transitional era in the history of ancient Chinese sculptural art during which the aesthetic concept of buxomness of Tang Dynasty gave way to the delicacy and slimness of Song Dynasty. The 14 acolyte Bodhisattvas as well as the 6 offering Bodhisattvas are all depicted as female characters, and although their facial features still maintain the

high Tang style of "curving eyebrows and chubby cheeks", their shoulders and limbs have apparently been elongated and become more delicate; their heights increased, and waist decreased. All these differences are corresponding to the stylish movements in the painting styles of late Tang and the Five Dynasties, i.e. moving towards the delicate artistic style of the Song Dynasty. Therefore, the East Main Hall sculptures are valuable examples for studying the aesthetic changes from Tang to Song, and in themselves also proving that they still manage to keep the way they used to look like.

3. The painted layer from Tang Dynasty has largely been lost. Although the central altar sculptures in the East Main Hall still maintain their original Tang style and appearances, but the painted layer, except for in very few hidden spots, has long been gone. Most of the remaining decorations were painted during Ming and Qing dynasties, such as the dragon robes on the three Buddhas, but the glaring colors of heavy red and blue are mostly from the Republic of China era.

4. The subjects of the sculptures showcase how inclusive the Tang art could be. The central altar statues in the East Main Hall are a combination of the

major subjects for contemporary Buddhist sculptures. Foguang Temple was a major Buddhist temple whose fame went far beyond the range of Mt. Wutai during Tang Dynasty, and the openness and inclusiveness of the characters of the temple are both indicative of and owing to the temple's distinguished status. Among the 5 main statues on the central altar, there are 3 Buddhas and 2 Bodhisattvas. The 3 Buddhas, however, are not the so called "Buddhas of the Three Times" that consist of Dipankara, Sakyamuni and Maitreya Buddha popularized during the Northern Dynasties, nor the "Buddhas of the Three Pure Lands" consisting of Amitabha, Sakyamuni and Bhaisajyaguru Buddha favored by the Song Dynasty, but instead a new version of Tryadhva Buddha that came around during late Northern Dynasties and went popular in Tang Dynasty—Amitabha from the western pure land, Maitreya from the future pure land, and Sakyamuni/ Vairocana Buddha from Saha/Avatamsaka world. This combination collectively represents all the major Buddhist schools of Tang Dynasty: Avatamsaka, Yogacara, Pure Land, and Tantric Buddhism—they were all co-exsting peacefully in the East Main Hall of Foguang Temple.

佛光寺东大殿佛塑分布示意图

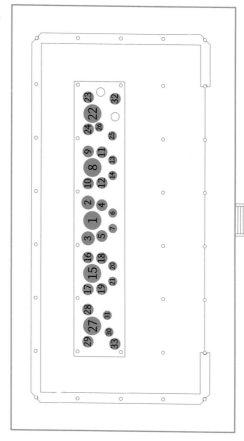

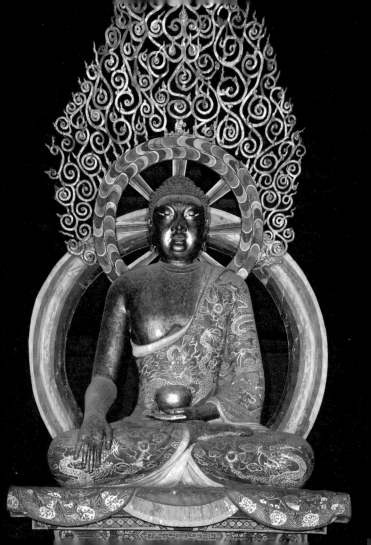

释迦牟尼佛 / 毗卢遮那佛像
The Statue Sakyamuni/Vairocana Buddha
(Height 5.37m)

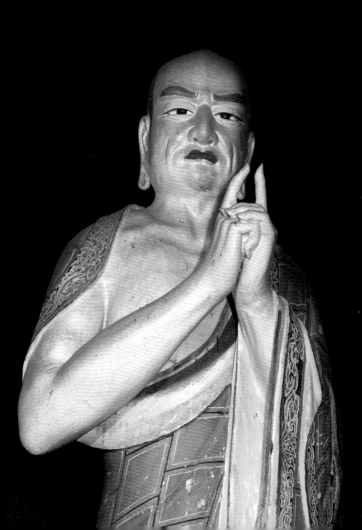

迦叶像

The statue of Kasyapa

(Height 3.46m)

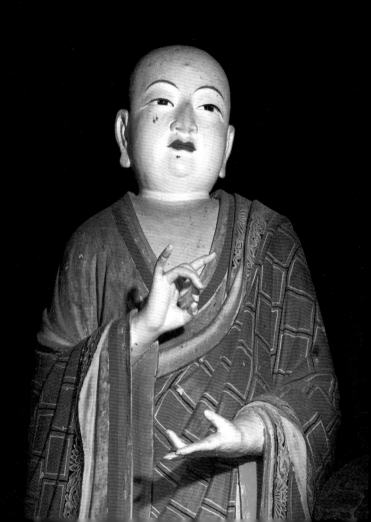

阿难像
The statue of Ananda
(Height 4.17m)

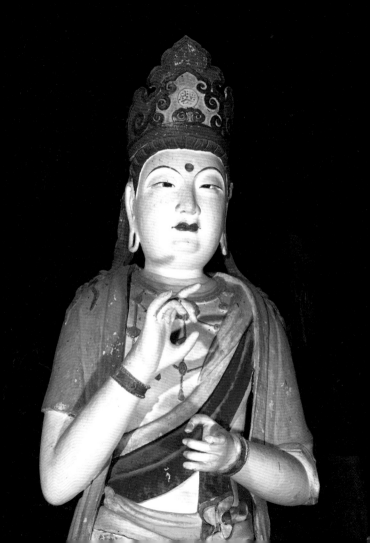

释迦牟尼佛 / 毗卢遮那佛左侧胁侍菩萨像

The Statue of the Acolyte Bodhisattva on the
Left Side of Sakyamuni/Vairocana Buddha
(Height 3.87m)

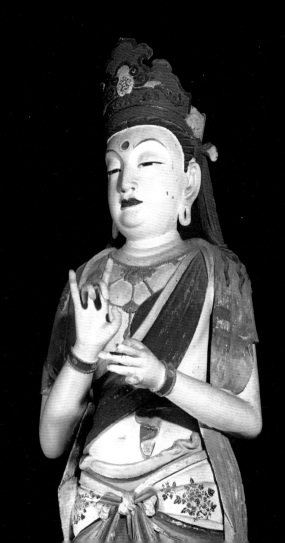

释迦牟尼佛 / 毗卢遮那佛右侧胁侍菩萨像
The Statue of the Acolyte Bodhisattva on the
Right Side of Sakyamuni/Vairocana Buddha
(Height 3.82m)

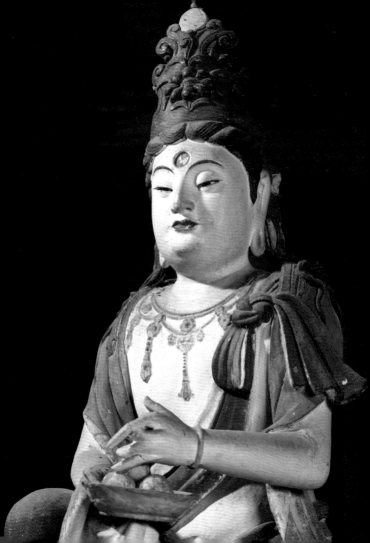

释迦牟尼佛 / 毗卢遮那佛左前侧供养菩萨像

The Statue of the Offering Bodhisattva on Left
Front of Sakyamuni/Vairocana Buddha
(Height 1.95m)

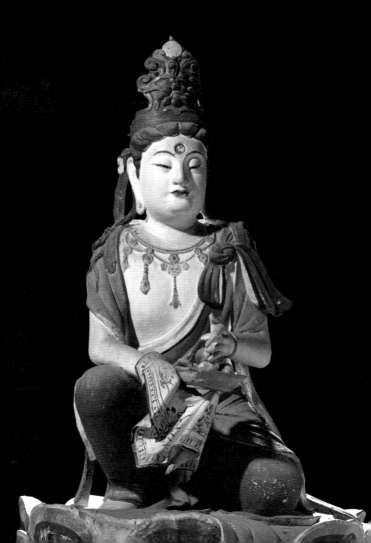

释迦牟尼佛 / 毗卢遮那佛左前侧供养菩萨像

The Statue of the Offering Bodhisattva on Left
Front of Sakyamuni/Vairocana Buddha
(Height 1.95m)

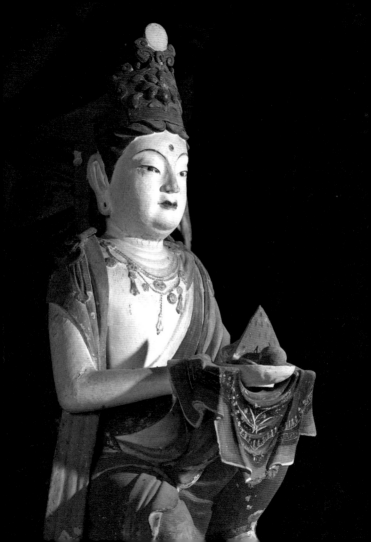

释迦牟尼佛 / 毗卢遮那佛右前侧供养菩萨像

The Statue of the Offering Bodhisattva on Right
Front of Sakyamuni/Vairocana Buddha
(Height 1.90m)

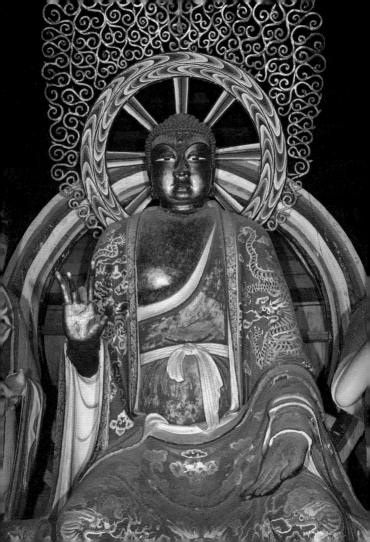

弥勒佛像

The Statue of Maitreya Buddha
(Height 5.38m)

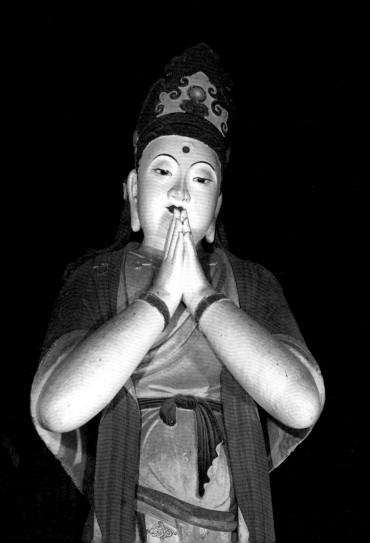

弥勒佛左侧胁侍菩萨像

The Statue of the Acolyte Bodhisattva on
the Left Side of Maitreya Buddha
(Height 4.20m)

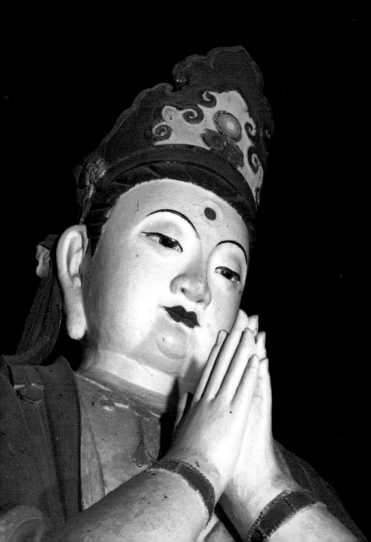

弥勒佛左侧胁侍菩萨像

The Statue of the Acolyte Bodhisattva on
the Left Side of Maitreya Buddha
(Height 4.20m)

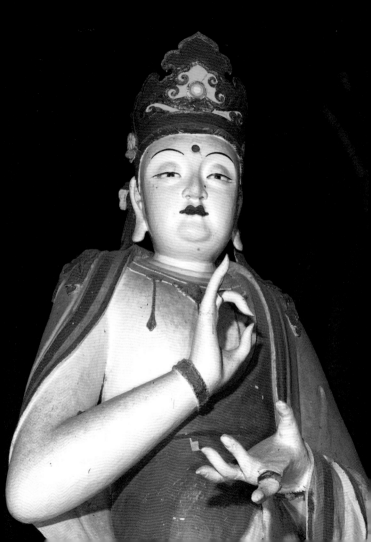

弥勒佛右侧胁侍菩萨像

The Statue of the Acolyte Bodhisattva on
the Right Side of Maitreya Buddha
(Height 4.32m)

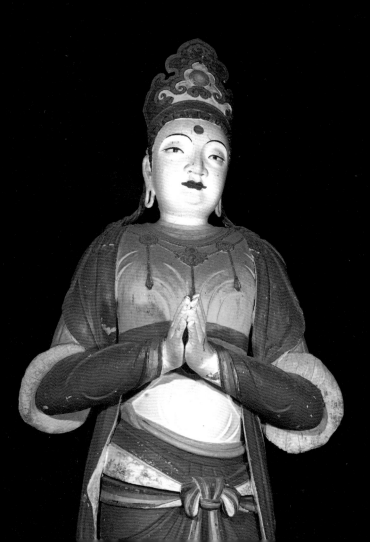

弥勒佛左前侧胁侍菩萨像

The Statue of the Acolyte Bodhisattva
on Left Front of Maitreya Buddha
(Height 3.74m)

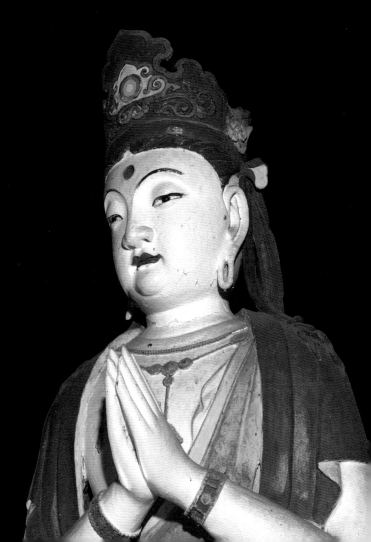

弥勒佛右前侧胁侍菩萨像

The Statue of the Acolyte Bodhisattva on
Right Front of Maitreya Buddha
(Height 3.77m)

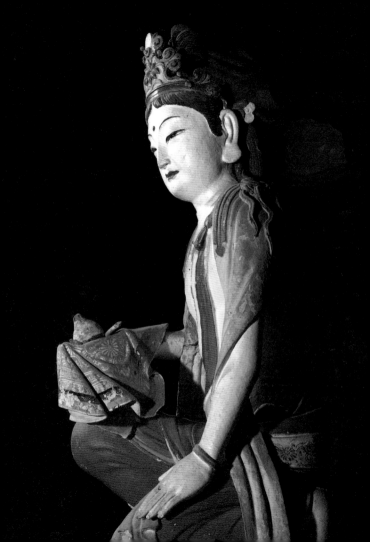

弥勒佛左前侧供养菩萨像

The Statue of the Offering Bodhisattva
on Left Front of Maitreya Buddha
(Height 1.91m)

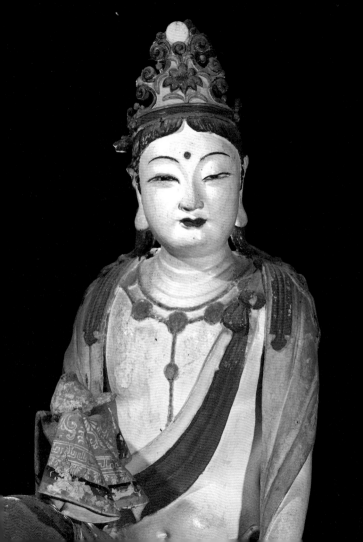

弥勒佛左前侧供养菩萨像

The Statue of the Offering Bodhisattva
on Left Front of Maitreya Buddha
(Height 1.91m)

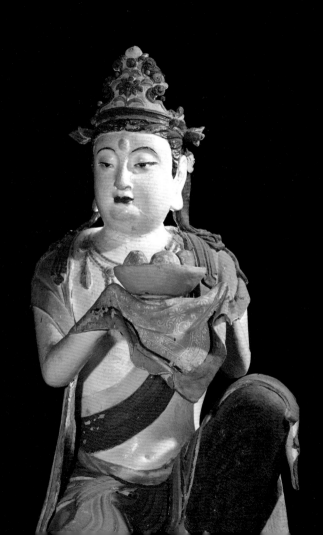

弥勒佛右前侧供养菩萨像

The Statue of the Offering Bodhisattva
on Right Front of Maitreya Buddha
(Height 1.90m)

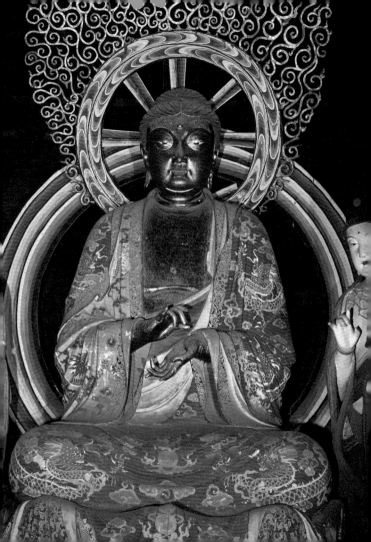

阿弥陀佛像

The Statue of Amitabha Buddha
(Height 5.19m)

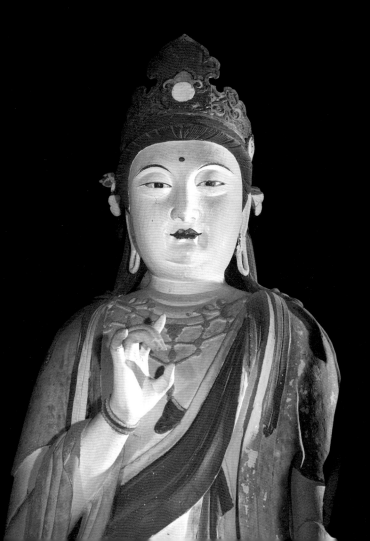

阿弥陀佛左侧胁侍菩萨像

The Statue of the Acolyte Bodhisattva on
the Left Side of Amitabha Buddha
(Height 3.84m)

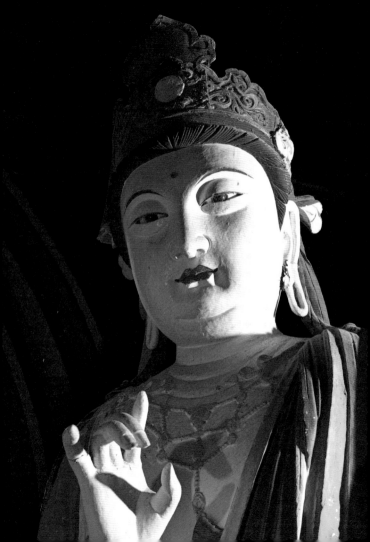

阿弥陀佛左侧胁侍菩萨像

The Statue of the Acolyte Bodhisattva on
the Left Side of Amitabha Buddha
(Height 3.84m)

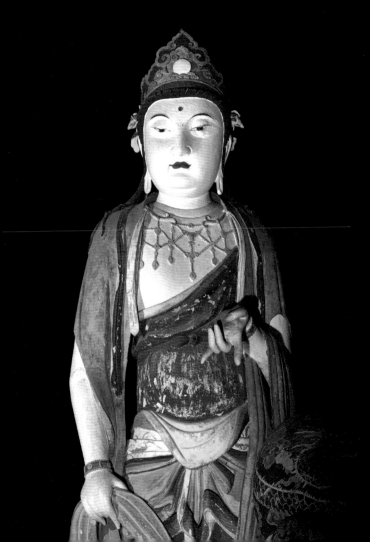

阿弥陀佛右侧胁侍菩萨像

The Statue of the Acolyte Bodhisattva on
the Right Side of Amitabha Buddha
(Height 4.24m)

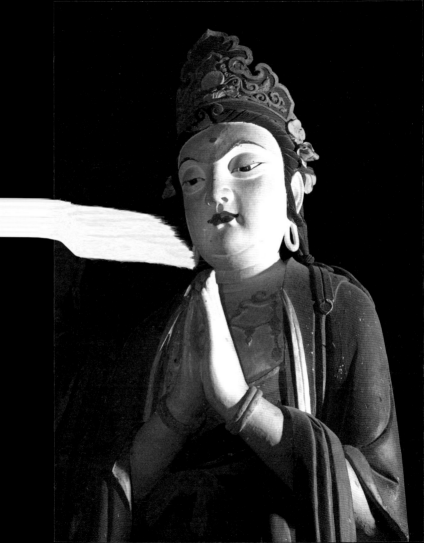

阿弥陀佛左前侧胁侍菩萨像

The Statue of the Acolyte Bodhisattva on
Left Front of Amitabha Buddha
(Height 3.88m)

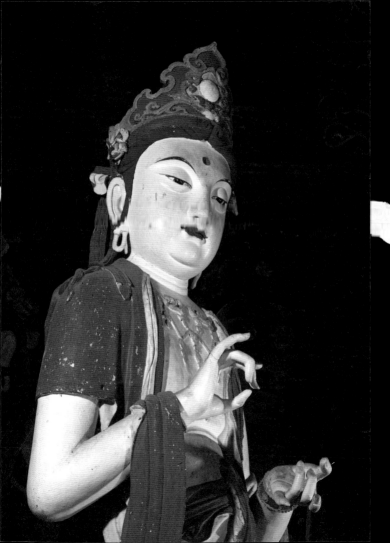

阿弥陀佛右前侧胁侍菩萨像

The Statue of the Acolyte Bodhisattva on
Right Front of Amitabha Buddha
(Height 4.31m)

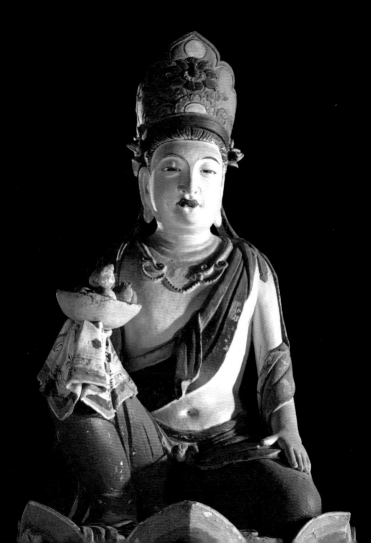

阿弥陀佛左前侧供养菩萨像

The Statue of the Offering Bodhisattva
on Left Front of Amitabha
(Height 1.88m)

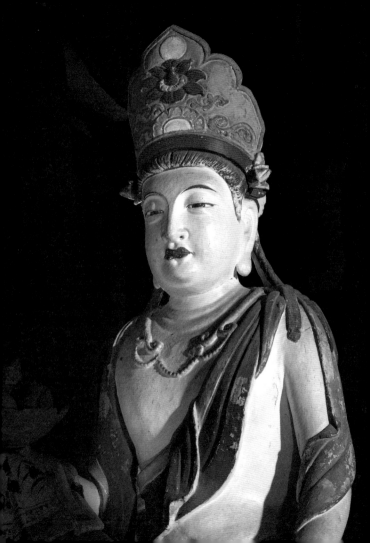

阿弥陀佛左前侧供养菩萨像

The Statue of the Offering Bodhisattva
on Left Front of Amitabha
(Height 1.88m)

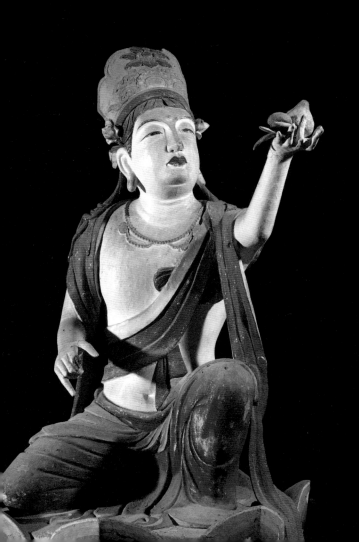

阿弥陀佛右前侧供养菩萨像

The Statue of the Offering Bodhisattva on
Right Front of Amitabha Buddha
(Height 1.82m)

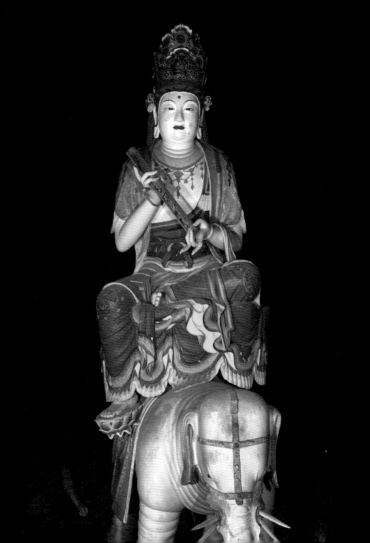

普贤菩萨像

The Statue of Samantabhadra Bodhisattva
(Height 4.94m)

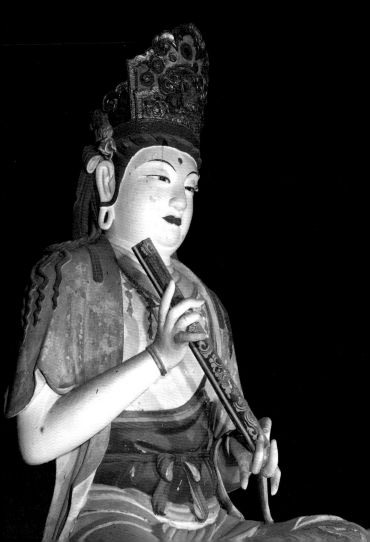

普贤菩萨像

The Statue of Samantabhadra Bodhisattva
(Height 4.94m)

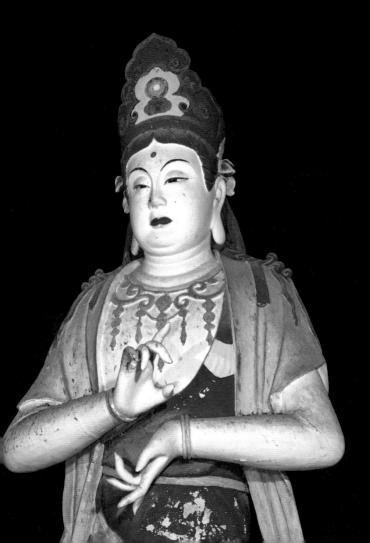

普贤菩萨左侧胁侍菩萨像

The Statue of the Acolyte Bodhisattva on the
Left Side of Samantabhadra Bodhisattva
(Height 3.86m)

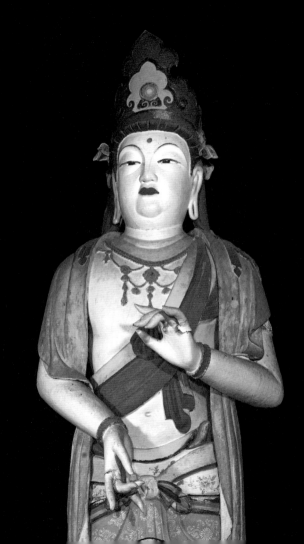

普贤菩萨右侧胁侍菩萨像

The Statue of the Acolyte Bodhisattva on the
Right Side of Samantabhadra Bodhisattva
(Height 3.77m)

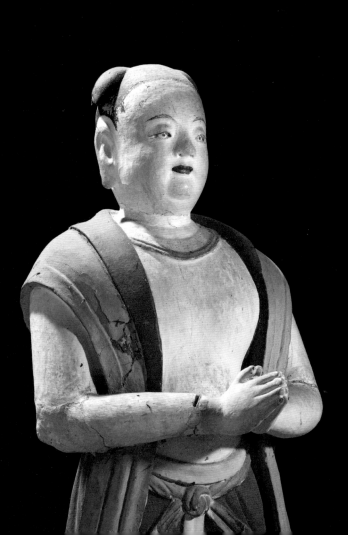

普贤菩萨右侧善财童子像

The Statue of Sudhanakumara on Right
Front of Samantabhadra Bodhisattva
(Height 1.17m)

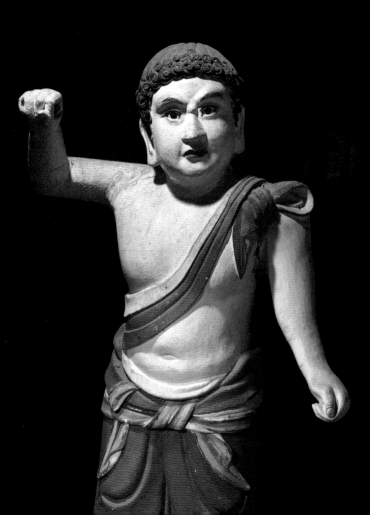

普贤菩萨右侧驭象童子像

The Statue of the Elephant Attendant on the
Right Side of Samantabhadra Bodhisattva
(Height 1.47m)

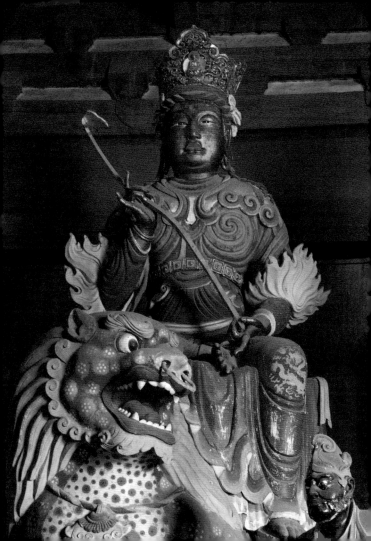

文殊菩萨像

The Statue of Manjusri Bodhisattva
(Heigh 4.88m)

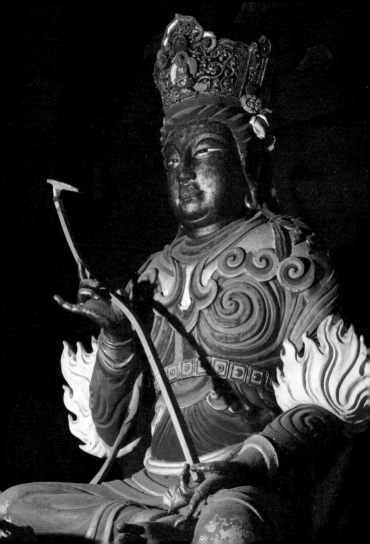

文殊菩萨像

The Statue of Manjusri Bodhisattva
(Heigh 4.88m)

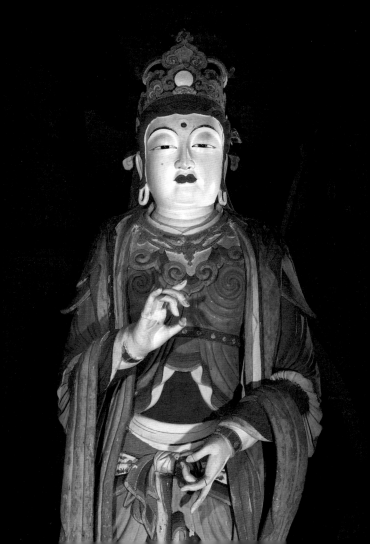

文殊菩萨左侧胁侍菩萨像

The Statue of the Acolyte Bodhisattva on
the Left Side of Manjusri Bodhisattva
(Height 4.10m)

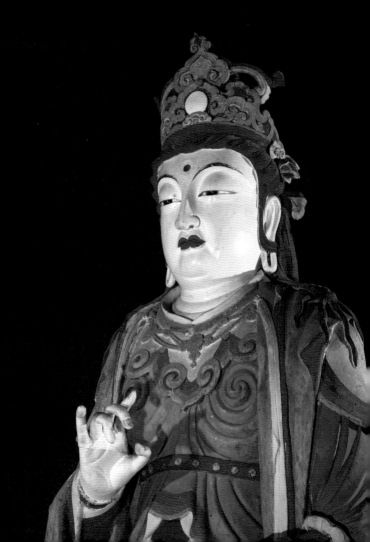

文殊菩萨左侧胁侍菩萨像

The Statue of the Acolyte Bodhisattva on
the Left Side of Manjusri Bodhisattva
(Height 4.10m)

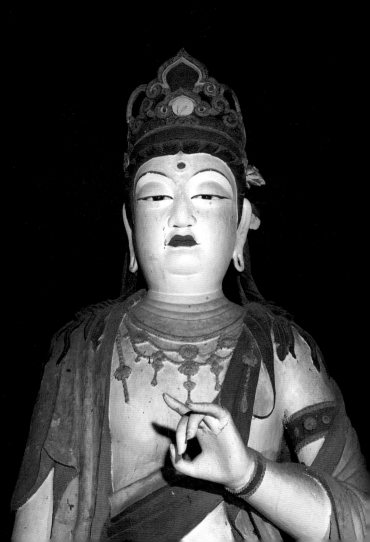

文殊菩萨右侧胁侍菩萨像

The Statue of the Acolyte Bodhisattva on
the Right Side of Manjusri Bodhisattva
(Height 3.90m)

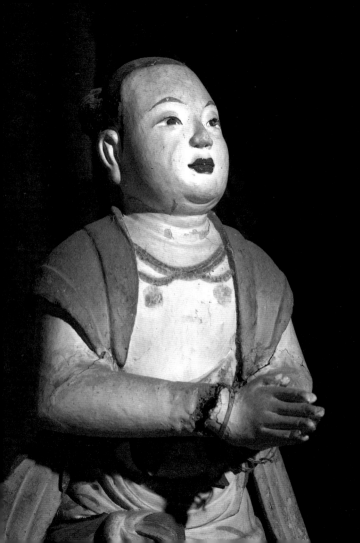

文殊菩萨右前侧善财童子像

The Statue of Sudhanakumara on Right front
right side of Manjusri Bodhisattva
(Height 1.27m)

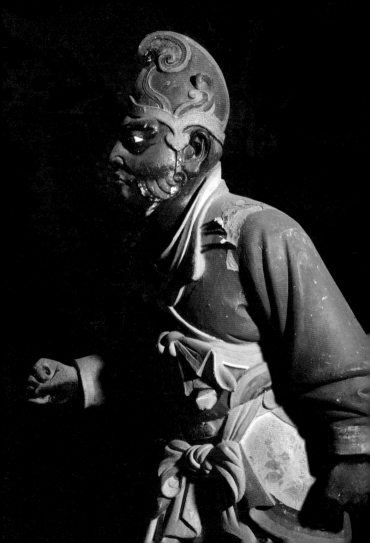

文殊菩萨左前侧驭狮于阗王像

The Statue of the King of Khotan as Lion Attendant
on Left Front Side of Manjusri Bodhisattva
(Height 1.68m)

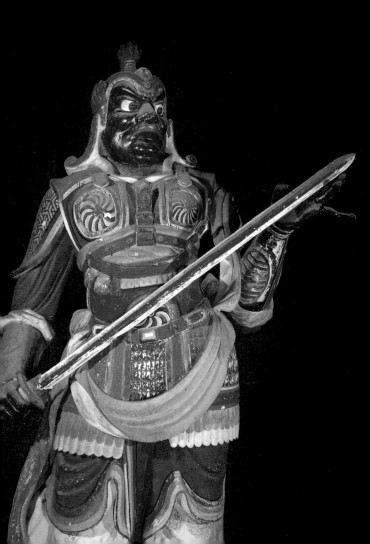

佛坛左前角护法天王像

The Heavenly Guardian King at the
Left Front Corner of the Altar
(Height 3.88m)

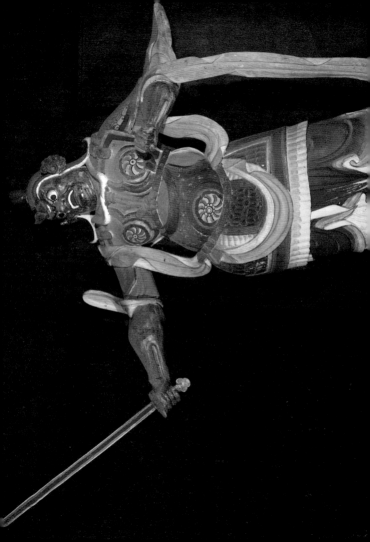

佛坛右前角护法天王像

The Heavenly Guardian King at the
Right Front corner of the Altar
(Height 4.16m)